CE LIVRE DE BANDES DESSINÉES APPARTIENT À:

..............................

DATE:

..............................

Some graphic elements in this book have been created by Starline, Macrovector, Winkimages - Freepik.com

No portion of this publication may be reproduced or transmitted in any form or by any means, electronic or mechanical, including, but not limited to, audio recordings, facsimiles, photocopying, or information storage and retrieval systems without explicit written permission from the author or publisher.

www.ingramcontent.com/pod-product-compliance
Lightning Source LLC
Chambersburg PA
CBHW081004170526
45158CB00010B/2907